G-Spot Play Guide:
7 Simple Steps to G-Spot Heaven!

by
Kim Switnicki

with
Barry Switnicki

Published by

ISBN 978-1-897518-83-0

Printed in Canada

Cover Design by Kumiko, Primal Communications
Audio Editing by Stewart McLellan Productions
Editing by Diane Akam, Barry Switnicki, and Tara Lenz
Position Illustrations by Rev
Technical Assistance by Dora Schievink
Book layout by Faye McCoole
Cover edit by Andrea Ink

DISCLAIMER

The advice contained in this material might not be suitable for everyone. Use any exercise program herein at your own risk. This or any other exercise program may result in injury. CONSULT YOUR PHYSICIAN BEFORE YOU BEGIN THIS OR ANY EXERCISE PROGRAM. The exercise program and information herein does not and is not intended to provide medical advice, recommendations, diagnosis, or treatment and is no way intended as a substitute for medical counseling. It is for educational and informational purposes.

To the maximum extent permitted by applicable law, Lioness for Lovers, Kim Switnicki, the creators, authors, owners, producers, contributors and distributors disclaim any and all liabilities, warranties or conditions (expenses implied or statutory) in connection with the exercise program herein.

To the maximum extent permitted by applicable law, in no event shall Lioness for Lovers, Kim Switnicki, the creators, authors, owners, producers, contributors and distributors be liable for any damage whatsoever arising out of or in any way related to the exercise program herein (including but not limited to, personal injury or death, loss of income, loss of profits, loss of use, direct, indirect, incidental, consequential, special, exemplary, punitive damages or any other pecuniary, economic, or other loss whatsoever arising out of or in any way related to the exercise program herein.

Dedication

I dedicate this book to all of the women and men who have shared their G-Spot joys and frustrations – you inspired me to open these gates to G-Spot Heaven!

Thank you to my sister, Diane, my cheerleader, and whose eagle eye is an editing wonder.

Special thanks to my dear friend, incredible artist and G-Spot wizard, Rev, whose drawings add flavour to the mix.

As always, to my loving husband, whose love and unconditional support brings me joy each and every day.

G-Spot PlayGuide: Seven Simple Steps to G-Spot Heaven!

INTRODUCTION

QUESTION: Who should read this PlayGuide?

ANSWER: Every woman who wants to deepen her sexual awareness and reach her sexual potential.

Although this PlayGuide is laid out with the assumption that you have someone to play with, you will still receive tremendous benefit by yourself as you explore and discover more about your sexuality. You can then share even more with your next partner. This G-Spot PlayGuide, the first in a series of PlayGuides, has been written as though you, the reader, are female and your partner is male. This is simply for ease of writing.

If you've experienced the power of a G-Spot orgasm before or even suspect you have, this PlayGuide will answer any questions while offering tips for improving your performance.

If you are pre-orgasmic (not had an orgasm yet) you will become skilled at expanding your self-loving skills and may find G-Spot exploration (instead of direct clitoral play) is *exactly* your ticket to orgasm ecstasy!

This PlayGuide supplies everything you need to enter G-Spot Heaven which is simply G-Spot pleasure and discovery – no orgasm required! The information and action steps will guide you to deeper sexual fulfillment. You'll find the guide simple, provocative and playful, not crass or complicated like some can be.

There is bonus material for you in Chapter 9. You can download three audio tracks from my website for free. You can also purchase them on an actual CD at a great discount if you prefer. The audios provide you with a powerful coaching process, the Sacred Sexy Circle, which will add even greater opportunities for you to reach your own sexual excellence. Download them now from www.lionessforlovers.com/sexycircle.htm so you'll be ready for Chapter 9. Call us if you have any questions or to order the CD at 1-888-475-2948.

Supremely successful people have two things in common: they set their sights on a goal or **set an intention** and they **write it down.** You can only create what you can visualize!

MY INTENTION IS:

(IT'S OKAY TO CHANGE IT TOO!)

BY THIS DATE:

Table of Contents

A Sexy New You in G-Spot Heaven

*"I think the quality of sexiness comes from within …
and it really doesn't have much to do with
breasts or thighs or the pout of your lips."*

Sophia Loren, Actress

Powerful and fulfilled, composed and secure. Have you ever seen those women who absolutely ooze sexuality regardless of how their bodies look? They dress to suit their body shape and have lovely posture and grace. They look great while waiting for a bus or stepping into a limousine. They dance like no-one or everyone is watching. Isn't that the type of woman you want to be? What is that woman's secret?

I'll tell you. **It's self-confidence!** These women **know who they are inside**. They know in their soul that they are sensual, sexual creatures. They virtually marinate in their self-assurance. Their poise and elegance is evident and they know and love it!

Do you remember any time in your life when you wanted to try something new? Perhaps it was riding a bicycle, doing the breast stroke or learning how to play Frisbee. Once you mastered the skill, or at least got pretty good at it, how did you feel about yourself? Didn't

you have a sense of freedom, a new confidence in yourself, and maybe some excitement and desire to share it with anyone who would watch you?

Now I don't suggest that you show off your new G-Spot skills to just anyone, but hopefully you get the point.

So why venture into G-Spot heaven? What are the deeper, more personal reasons for expanding your sexual horizon with the 'mysterious' G-Spot? I invite you to take a few moments for yourself, be still and quiet and play along a little with me…

Sit back, take a few DEEP breaths, look up and softly close your eyes. Think of a time when you felt your most sensual, most sexually fulfilled. Experience that feeling again. If you can't recall a time like that, think of someone who embodies all of that for you. Imagine a movie screen is up in front of you and you SEE a wonderful movie starring the incredible **You!**

In this movie you are *feeling* and *being* that sensual and sexual woman. You're experiencing the bliss of complete and total sexual satisfaction. What do you see yourself doing, how are you feeling, what sounds do you hear, what aromas do you smell? Increase the intensity…
Then step up into the movie and experience all of the sights, scents, sounds and feelings. Enjoy the intensity…

When you're ready, gently step down out of your movie. Remember all that you felt being that sensual, sexually satisfied woman in your movie. Take your time and answer the following questions as thoughtfully as you can:

Who **will you be** as a lover, partner or wife when you discover the secrets of your G-Spot (examples: more fun, vibrant, playful, increased confidence, more desirable, less stressed)?

How will your relationship with your partner be changed as a result of your new found sexual mastery?

Who else benefits from your increased sexual awareness and deeper satisfaction? When satisfied, you will act differently everywhere you go.

What drives or propels you to seek out your G-Spot and why is it so important to you?

What will you model for the younger women in your life?

How will you be different with your partner, family and your co-workers?

> Over 90% of women I speak with tell me they can have incredibly satisfying sexual encounters **without an orgasm!**

Our society is very goal driven and that's really not what lovemaking should be all about. Just like life, your sexual happiness should be a *journey* of peaks and valleys taking you through the soaring heights of pleasure, riveting moments of bliss and hours of languishing, mellow arousal and NOT a destination of orgasms notched on your bedpost.

While every woman has a G-Spot, you may not have a G-Spot orgasm and that's perfectly okay. You can still enjoy G-Spot Heaven!

For my "Top 10 Ways to be Sexier and more Confident," go to www.lionessforlovers.com and sign-up for my free special report.

YOUR *SEXY* MISSION

❑ Write down your answers to the questions in Chapter One.

❑ Commit to acknowledging all of your achievements from this point forward. The key to your success is the celebration step! Remember winning a ribbon in Track and Field at school, getting an "A" on a test or even a gold star from the teacher? Marking your goals and acknowledging when you meet them sets up the dynamic for feeling successful. It is critical that you not only ARE successful but that you stop and actually FEEL your success and celebrate it!

SENSATIONAL *CELEBRATION*

❑ How will you celebrate your completed Sexy Missions?

❑ When will you celebrate? (Record the specific date and time and schedule it into your planner or calendar! Being detailed increases your likelihood of success.)

We, as women, are notorious for not celebrating our accomplishments. We tend to focus on what we haven't done. Take another step towards success and practice the art of celebration! It may be something very simple that only takes a few minutes. Couldn't you use a little more celebration in your life?

SOME CELEBRATION IDEAS TO GET YOU STARTED:

⌁ have a quiet cup of tea

⌁ pat yourself on the back

⌁ take a half hour walk

⌁ go for a test drive in the car of your dreams

⌁ play with your kids for 20 minutes

⌁ take yourself to your favourite coffee shop

⌁ treat yourself to a new pair of shoes

⌁ buy a new lipstick (hmm, perhaps a sexy red)

⌁ reach out by letter, text, email or phone to a friend that you haven't spoken to in a long time

- paint your toenails a delicious colour you normally wouldn't wear – just for fun

- eat mangoes naked

- plan a Potluck Girls Night

- buy yourself an ice cream cone and practice sexy tongue techniques

- kiss someone you love – like you really mean it!

- make time for a long, hot bubble bath

- buy yourself flowers

- write a love letter to yourself

- mail a love letter to yourself, open it, read it and frame it!

- secretly say to yourself "I love you" over and over and over and notice how you feel

- create a special room (or corner or closet) that is JUST for you to meditate, read or relax in

Please drop an email to kim@lionessforlovers.com to share some of your celebrations. I love hearing them!

2

Getting the Most from this Play Guide

*"Nobody cares if you can't dance well. Just get up and dance.
Great dancers are not great because of their technique,
they are great because of their passion."*
Martha Graham, Choreographer

One of the best things to have is the right attitude. Sexual exploration can be exciting, scary or fun and it is sometimes all of those things simultaneously. It is also one of the most rewarding things you can do for yourself and your intimate relationships. The more you gain sexually, the greater the benefit throughout your entire life.

Relax and have as much fun as you can. You can participate in this journey alone or with a partner. Try enrolling someone to support you as you move through the steps. Don't do anything that you don't feel comfortable with and remember: there are only right answers – you stand only to gain heaps of pleasure!

In Chapter 13 you'll find out more ways you can continue your sexual success journey including another free audio bonus of Kim's live G-Spot Workshop. Plus you'll receive a special discount code for online product orders. Allow Lioness for Lovers to help you reach your sexual potential!

G-Spot Heaven in 7 Simple Steps

USE MY *L.I.O.N.E.S.S.*™ TECHNIQUE

L	I	O	N	E	S	S
Learn	Investigate	Options	Next	Enhancements	Share	Success

1. LEARN the basics. As with any other topic, knowledge is power, so to become Sexually Empowered, you need to learn as much as you can.

2. INVESTIGATE further. This is where you take a hands-on approach to explore and discover the intricacies and uniqueness of your own G-Spot.

3. OPTIONS. Find out more about sexy G-Spot toys and the elusive Male G-Spot.

4. NEXT steps takes you through some advanced techniques for getting even more pleasure from your body!

5. ENHANCE all of your learning with a professional coaching process designed to permanently alter your sexual future. Commit to taking charge of your sex life and entering G-Spot Heaven.

6. SHARE what you have learned with your partner. Don't worry, we give you lots of tips to make this fun, easy and very rewarding.

7. SUCCESS and support. Get committed to continuing your journey not only through G-Spot Heaven, but beyond!

G-SPOT PLAYGUIDE INSTRUCTIONS:

- ✐ Quickly scan through the book to familiarize yourself with the chapter contents.

- ✐ Set your intention and WRITE IT DOWN in the space provided in the Introduction.

- ✐ Do each of Your Sexy Missions. Put a check in the boxes when you're done.

- ✐ Most importantly, Celebrate! Check that box too!

SEXY G-SPOT TIPS:

Keep towels available when you are playing with your G-Spot on the chance that you trigger a female ejaculation. More about that in Chapter Five.

As for tools, a hand-held mirror, some lubricant, your hands and your mouth (for talking with your partner!) are all that are required. There is a section on G-Spot toys (Chapter Six) but they aren't absolutely necessary. A partner isn't even needed but does make things easier and once you get used to it, a lot more fun!

If you miss some of your Sexy Missions or Sensational Celebrations, please don't worry about it – simply pick up where you left off. This is not meant to be a chore on your to-do list.

3

G-Spot History and Anatomy: Where the Heck Is It?
(LEARN)

"I don't mind living in a man's world as long as I can be a woman in it."
Marilyn Monroe, Actress

Why would you want to know the specifics of your anatomy and specifically the G-Spot? Recent discoveries actually suggest the G-Spot is part of the clitoral system. Not all medical experts agree, and we won't explore that discussion within this PlayGuide, yet it is significant for women that attention is finally being put on our sexual pleasure and what drives it.

The G-Spot has been around for hundreds of years. It has been known in Taoist circles as the 'black pearl,' has been revered by Tantrics as the 'sacred spot,' it was mentioned in the Kama Sutra writings and was often depicted in ancient Japanese art paintings as a woman overcome with sensual delight and squirting liquid out from between her legs.

It re-emerged in medical literature in the 1940s. Women can credit the naming of this magical area to gynecologist Dr. Ernst Gräfenberg who first described it in 1944. It created quite a stir back then and still does!

Before we get to the actual G-Spot, let's back up briefly and look at your sexual anatomy in general. Here is the Vulva in all her glory. Viva la Vulva!

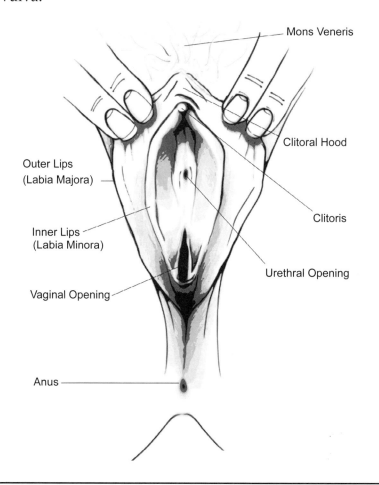

Mons Veneris

Clitoral Hood

Outer Lips
(Labia Majora)

Clitoris

Inner Lips
(Labia Minora)

Urethral Opening

Vaginal Opening

Anus

Where the inner lips connect at the top rests the magic button of the clitoris whose only purpose is your sexual pleasure! Please remember that!

The vulva is basically our external genitalia. The vagina is inside of you so it is NOT part of the vulva, although the 'opening' to the vagina is part of it. Our vulvas are all very unique in size, shape and colours yet the basic parts should be the same.

Note the urethral opening which is where your urine comes out. This is also where female ejaculate comes out! More about that in Chapter 5.

The labia (lips) may be different colours, shapes and sizes, but the inner lips are hairless and the outer ones are fleshy and have hair. Where the inner lips meet at the top is the clitoris which has no other use but to give you exquisite joy when stimulated (and some women don't even need it touched to swoon). The clitoris is often thought of as the primary sexual organ in the female.

In fact, **a woman's primary sexual organ is her brain** and without its co-operation, orgasm can be a challenge. We actually need to turn off part of our brain to achieve our sexual peak. It has been proven that if the 'amygdala' (where fear and anxiety live in our brains) is engaged, we can't get aroused to orgasm. So no more thinking about work, appointments, or shopping while making love! Instead, encourage your lover to give you a foot rub (or hand massage if you prefer) to help you unwind. This will help you hop on the arousal train much quicker!

Printable Vulva poster at
http://www.lionessforlovers.com/images/posters/vulva_poster.jpg

A lot of women know they have a certain 'spot' between their legs that brings them a lot of pleasure when touched, licked or rubbed, but they don't really know much about it. This magic button is the clitoris (pronounced klĭt´ər-ĭs or klĭ-tôr´ĭs) and is a fabulous reason to be a woman!

I spoke with a man who spent many years happily performing oral sex on women without knowing where the clitoris was. I asked him about it and he said he just licked and nibbled all over her 'privates' and hoped his ladies enjoyed themselves. After I gave him a brief education, he was excited to go and test his newfound knowledge on his latest lady. I hear she was pleasantly surprised!

Let's take a look at the clitoral system which is more complex than most women realize. It is also much larger than most experts had imagined.

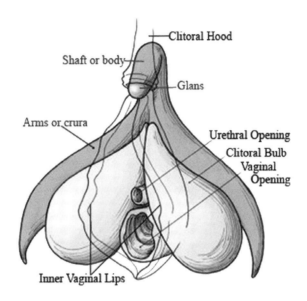

The glans of the clitoris has 8,000 nerve endings which is the most concentrated amount of nerve endings in all of the human anatomy. I call it the "Tip of the Clitoral Iceberg." The penis has between 4,000 and 8,000 nerve endings in the whole entire length of it!

There are a lot of components. The clitoral glans is attached to a body which goes in behind the pubic bone and wraps around three sides of the urethral tube. The arms (or crura) tuck in and follow down along the opening of the vagina on either side. There's a lot more to the clitoris but these are the basics.

Now for the G-Spot! As you can see in the diagram, it is not actually in the vagina but felt through the front wall of the vagina. Her finger is pushing up towards her G-Spot! Technically it is **in the urethral sponge** which wraps around the urethral tube. The urethral sponge is full of erectile tissue, glands, ducts and loads of nerve endings that give many women sexual sensation when stimulated the proper way!

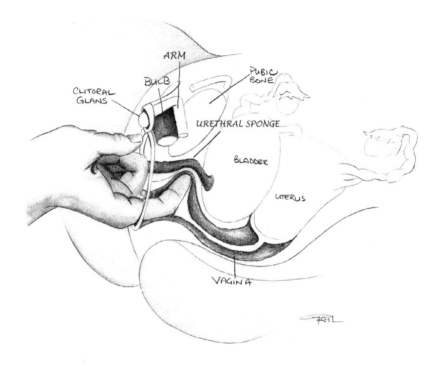

When a woman becomes aroused, this tissue swells (as do her vaginal walls, labia, etc.) and when the sponge is properly stroked, rubbed or vibrated you can reach heights of bliss you may not have known possible.

One of the keys to G-Spot play is to first be aroused. If you aren't turned on and the tissue is relaxed, you may only feel irritation, though some women still find it enjoyable.

Note the urethra leads directly to the bladder. If your bladder is full when you are being stimulated, it can be uncomfortable. Some women enjoy the feeling of pressure so it's a personal choice whether you empty your bladder or not. I suggest you practice first with an empty bladder when first starting out.

If you were to lie on your back and insert a finger, it would be about half way between your belly button and your vaginal opening or at the end of your index finger. It may be slightly to the right or left of center so move around! If you are aroused, you'll feel a difference in tissue in this area. It may feel hard, tough, ridged or bumpy. The areas will vary in size for each woman but is often described as about the size of a pea or a dime and can be shaped like a cashew or licorice. The actual vaginal walls are smooth, though there are lots of folds of skin, and the walls aren't as sensitive as you go in deeper.

Since there aren't nearly as many nerve endings as there are in the glans of the clitoris, the G-Spot needs a lot more stimulation. If you are using your finger(s) first, make sure you are lubricated. Try a tapping, hard stroking or rubbing motion.

What you're feeling for is the urethral sponge on the other side of the vaginal wall. You may love it, hate it or be ambivalent, but either way, you'll feel something!

Some experimentation is in order. Some women find all of the sponge is responsive to sexual stimulation. Some prefer applying pressure outside around the urethral opening. Some find a very specific 'spot' that drives them wild. You really need to explore to see what works best for you!

Kathy Gruver, an in-home massage therapist in California, relates this story about a 94 year old female client who enjoyed sexual discussions:

"While I waited for her to be ready for her massage, I noticed an article from the newspaper about some Planned Parenthood lectures. She came into the room ready for her massage and got on the table, here's the conversation:

L: Kathy, you seem to know about a lot of stuff. Can I ask you a question?

K: Sure

L: What's my 6-spot?

K: (because of the article I knew she misread "G-Spot") Do you mean G-Spot?

L: I guess. Is that what it is? I just read about that and I don't think I have one.

K: Yeah, I'm pretty sure you do.

L: Well, I'm not sure and I'm wondering if you could touch it for me so I'd know where it is.

K: Well, you know it's inside you, I can't really do that.

L: No, the article said it was behind the pubic bone.

K: Well, yes, it's behind the pubic bone but, in your vagina.
 [Kim's note: it is actually felt through the vaginal wall.]

L: Oh

K: Yeah, so I can't really do that.

L: Well, I thought the article said it was on the outside.

K: (At this point I needed a visual to show her where the G-Spot would be in relation to her cervix, etc., so I cupped my hand in a C shape and stuck my finger from my other hand out into the cupped portion to represent the cervix.)

L: Oh. Well how do I get to it?

K: Well, it's kinda hard to get to with your own fingers (knowing her age), so, well, I guess a penis or a dildo.

She was quiet for a second and then said:

L: Darn it, I got rid of my dildo years ago.

And then we moved on to the next conversation. I did tell her if I found a penis, I'd bring it for her.

I got home and relayed this conversation to my husband. Now the talk with her was very serious. No laughing at all and in telling my husband I realized how hysterical it was. I also asked him if he was going to be willing to help me find my G-Spot at 95. He did admit he'd be dead by then so I guess I'll have to find me one of them young 86 year olds."

YOUR *SEXY* MISSION

❑ Treat yourself to some time, privacy and love. Have a hot bath or shower and prepare yourself for pleasure. Masturbate to orgasm. This way you know you are completely aroused and the tissues will be swollen. If you don't orgasm, caress and play with yourself, fantasize and do what you do to become aroused. Perhaps an erotic story or movie will help! Ensure you are lubricated, slip your finger inside your vagina and apply upward pressure on the front wall aiming for your belly button. Fantasize about something erotic while you try to find your G-Spot. See if you can detect pleasurable sensations. This is strictly an exploration, but if you find it really pleasurable, please continue!

To learn more about sexuality topics such as fantasy, masturbation, vaginal health, sexual frequency, or anal play, sign up for our free "Sexual Truth" calls and boost your sexual confidence even more! Go to www.lionessforlovers.com and 'Sexual Truth' on the menu.

SENSATIONAL *CELEBRATION*

❏ How will you celebrate your completed Sexy Missions?

❏ When will you celebrate? (Record the specific date and time and schedule it into your planner or calendar! Being detailed increases your likelihood of success.)

4

The Anatomy of Your Orgasms
(LEARN)

"The soul should always stand ajar,
ready to welcome the ecstatic experience."
Emily Dickinson, poet

How would you like to have more orgasms? Understanding how they work may just do that for you.

Let's start at the beginning with what happens as soon as the arousal period has begun. The first physical indicator of arousal in a woman is usually lubrication. There are tiny ducts and glands in the vagina and at the vaginal opening that secrete fluid to ease the process of penetration.

There are many factors that affect a woman's ability to lubricate:

- If you are under stress or tired, you won't lubricate as well.

- If you're drinking alcohol or taking any drugs, over-the-counter or otherwise, you will find you are drier.

- If you are taking hormone affecting drugs (such as the birth control) or have had any surgeries affecting your hormones, your capacity for producing wetness for slippery penetration is impacted.

So if you enjoy a drink to de-stress after a long week, don't expect your plumbing to produce as much moisture for you that evening!

It's important for you to know the factors that affect this significant component to a sensational sexual experience and pass this information along to your partner. You don't want him thinking he doesn't turn you on anymore (which he may assume because you're dry) when in fact you've been taking allergy medication which dries up the mucous membranes in your nose and between your legs!

Lubricant is the most important sexual empowerment accessory you can have in your collection – and I'm a huge fan of flavoured lube. Just be very careful that you use a water soluble lubricant. Oils do not break down well in the vagina so if you use an oil based lubricant you create a breeding ground for bacteria. We have a slippery, long lasting, safe, flavoured lubricant on our website that is naturally flavoured so it tastes great!

> Go to www.lionessforlovers.com and click on Sexy Essentials to see our lubricants. Remember lubricant is significant for super sex!

As you become aroused, the vaginal walls become engorged and they expand. So does your entire clitoris (yes, it gets a mini erection!) as well as your G-Spot area and other tissues in the Vulva. When you are fully aroused, your vagina tilts and shifts back as does your uterus and cervix. Since your vagina is only about four inches deep or so,

you need to wait for full arousal so your pelvic floor is prepared for penetration.

Tension builds up as you near orgasm – which is actually a massive release of that tension in a series of contractions. It may not sound very sophisticated, but a climax, especially with someone you care about, can be one of the most powerful and awe inspiring feelings the human body experiences.

It's important for you to let your partner know that you want him to keep doing what he's doing if you're close to orgasm. He may not be aware that if the movement or sensation is changed, and we're close to our peak, we can get thrown off course quite easily. We don't have the 'point of no return' in the way men do.

As for that feeling of bladder urgency that stops many women in their tracks, first of all:

you can't orgasm and urinate at the same time!

There's a bladder sphincter that closes the urethral tube when you climax. Some women with weakened pelvic floor muscles or weak sphincters may experience a bit of urine leakage during the contractions of orgasm, but even this is very rare!

I created a complete program for women to tone these muscles and get their lives back called "Freedom from your Leaky Bladder!" See Chapter 13 for more information.

With G-Spot stimulation, the sense of bladder pressure and feeling of impending urination can be quite strong in some women as they get closer to orgasm even though they will not actually urinate.

For some women, especially those who haven't experienced orgasm yet, feeling like they have to pee is the closest thing they can relate the sensation to and they stop! Many women have finally pushed through this feeling and finally had the experience of their first orgasm!

When aroused, a lot of tissue swells and if your bladder isn't empty, the swelled tissue can apply pressure to the bladder that may give you a feeling of urgency. Also, direct stimulation of the G-Spot may also be pressure on your bladder. For some women, the pressure feeling with a fuller bladder is a turn-on.

My recommendation is to *do whatever feels best for you*! That's my main rule.

Healthy sexuality is 100% consensual and brings pleasure to all participants. Go with what feels right for you.

"My first G-Spot experience occurred when my lover was performing oral sex on me. I was enjoying the clitoral stimulation and then I was suddenly overcome with such intense feelings of pleasure deep inside me. I had no idea what was happening inside or out. I remember saying "I don't know what you're doing but please don't stop!" I couldn't tell what was going on but later discovered that she had two fingers inside me stimulating my G-Spot and the result was the most mind blowing orgasm I had ever had!" *Name withheld, Toronto, Canada.*

Over the years, orgasm or climax has been broken down into two basic primary types for women, though there are an infinite variety of ways to achieve them.

The two types of orgasms people refer to are:

- a clitoral orgasm which is accomplished by direct stimulation of the glans (or head) of the clitoris through some type of external clitoral activity such with a finger, sex toy or tongue playing with it

 or

- a vaginal or G-Spot orgasm which is mainly attained by internal attention by either a finger, sex toy or penis applying pressure, stroking or thrusting in and out or staying within the vagina

A multiple orgasm is simply being able to have more than one orgasm in a lovemaking or masturbation (which is self-love!) session. Betty Dodson (author of 'Sex for One' and 'Orgasms for Two' available on our website) calls them serial orgasms which seems a lot more accurate since most women (not all) need a short break in between each orgasm. The clitoris gets hyper-sensitive, similar to the penis, after each orgasm, so you either let up considerably on the stimulation or stop it altogether for a few seconds or a few minutes and then resume the build up again.

WHAT TYPE(S) OF ORGASM(S) DO YOU HAVE?

I invite you to set a powerful intention to explore having more or different orgasms perhaps expanding your sexual comfort zone (such as "I will explore G-Spot orgasms to add to my sexual pleasure" or "I will explore clitoral orgasms with a vibrator").

WRITE YOUR ORGASM INTENTION BELOW:

YOUR *SEXY* MISSION

❑ You need a small compact mirror or a hand-held mirror for this one. Take A LOT of extra time arousing yourself and playing with all the different parts of your sexual anatomy. Play close attention to any new ones you may have just discovered. Be in a private and comfortable location and begin to masturbate. FEEL when you begin to lubricate and when you begin to swell.

During different stages use the mirror to watch the changes as they occur. Ideally, prop it perhaps on a pillow in front of you if you can sit up in bed while you explore, play and admire your vulva. Feel the clitoral erection, see the glistening of your lubrication, admire yourself as you swell and enjoy the engorging of blood into your labia and notice the change in colours. You may notice a large difference especially around the urethral opening.

Continue to play with your clitoris and even inside your vagina and bring yourself to orgasm. As soon as you're able, look in the mirror while, or immediately after, you orgasm to watch your contractions. It's quite an amazing sight!

SENSATIONAL *CELEBRATION*

❏ How will you celebrate your completed Sexy Missions?

❏ When will you celebrate? (Record the specific date and time and schedule it into your planner or calendar! Being detailed increases your likelihood of success.)

Stimulate Your G-Spot Yourself: A Hands-On Approach
(INVESTIGATE)

"Adventure is worthwhile in itself."
Amelia Earhart, Aviator

Why would you want to play with your own G-Spot? Have you ever learned a new dance step maybe from a friend or in a class? Did you go out into public immediately and try it out? Some of you may have. A lot of us like to practice first. Perhaps in the living room, basement or in that same dance class. When we feel more comfortable, we take it to the dance floor out in public.

When it comes to our bodies, we are often more comfortable and at ease when we're alone than when someone else is in the room. Have you ever found that you can reach orgasm quicker when you masturbate alone than when you're with your partner?

Likewise with G-Spot play. You're less likely to be successful with someone else for your first time so set yourself up to win. Get comfortable with your G-Spot before showing it off to your partner. Consider this your dress rehearsal. This practice improves your chances of G-Spot victory.

1. Set the scene and get into a quiet and private space where your mind is relaxed. Perhaps a hot bath with scented oils and candles and soft music to calm you. Open your mind to the wonders of what you may discover. You may want to re-visit Chapter One where you wrote out all the marvelous benefits you will experience from expanding your sexual horizons.

2. Before you begin, ensure your bladder is empty and you have a water soluble lubricant.

3. Have towels handy in case you experience the joys of female ejaculation. We discuss this later in the chapter.

4. You want to make sure you are aroused before you insert your finger into your vagina. One of the easiest ways is to masturbate for a little while so you're wet and ready for penetration. If you aren't turned on, your urethral sponge won't be swollen so you may not find your G-Spot!

5. When you're ready, consider what position you want to be in first. Some women prefer to kneel upright, some prefer to be on their knees and leaning forward, some prefer laying on their tummies and some prefer laying on their backs. I recommend trying a few positions since the sensations can be quite different.

6. Try playing with the opening to the vagina first and apply pressure to your urethral opening – some women find this incredibly erotic. You may also really enjoy playing with your vaginal lips. Remember, the arms of the clitoris tuck in along either side of the vaginal opening so intense lip play can act like a tuning fork sending sensation all the way up to the glans of the clitoris!

7. When you're ready, gently slip your index finger into your vagina and curve it so it strokes the upper wall pointing toward your belly button.

8. Since there aren't the same number of nerve endings inside the vagina or in the urethral sponge as there are in the clitoral glans (8,000), you need to apply strong pressure, hard stroking, a tapping motion or vibration to achieve results with the G-Spot.

9. Feel around starting at the top center or 12 o'clock position applying as much pressure as you can. (Partners with forearm strength like guitarists, rock climbers or baseball players are keepers!) Then go to the right to 1 o'clock and all around the opening to 2 o'clock, 3 o'clock and so on and notice how it all feels. You may need to switch fingers at some point so you can make it all the way around. What position gives you the strongest sensation?

Luckily most of the nerve endings are concentrated in the first three inches just inside the vaginal opening so a finger is all you really need. I know a woman who had a lover with a three-inch penis and he rocked her world because he always hit her G-Spot with it – he was just the right size!

Most women who experience G-Spot orgasms note that the difference between these and clitoral orgasms is that they are more of a lower, full feeling and are brought on by pushing to bring them on. If you start to sense bladder urgency, remember you won't actually urinate. The trick is to push or bear down instead of tensing up or stopping. It's like uterine contractions only much more pleasurable. See how far you can go with it!

The more you have G-Spot orgasms the more easily they will happen.

As for female ejaculation, it is an absolute truth!

Shannon R., from San Dimas, California shares her experience of her fiancé introducing her to G-Spot pleasure.

"When my fiancée first "played" with me stimulating my G-Spot, it threw me over the edge. At first I couldn't harness it enough for an orgasm, but with his patience I was able to harness it … with pleasure!

Together we mastered being able to make me squirt, too. That's an even more intense orgasm than just a G-Spot climax. He went online and read up on the best methods. He tried different techniques until we figured out which ones worked best.

The best position for me is lying on my back with him on the side but on his knees. He can use his other hand to stimulate other areas or push on the top of the G-Spot area from the outside to increase the internal stimulation. It also allows me to still keep in "touch" with him with my hands.

I actually love to get fisted (it sounds more painful than it is!) and that is a guaranteed way to make me squirt and orgasm from the G-Spot. However, the best position for that is doggy-style with him behind me like normal, but with his hand inside instead. This also avoids any mis-movement from him and hitting a nerve (bad thing) as I squirm with pleasure. The first time I squirted I couldn't believe it was something real!! It is the BEST release of them all."

To test your own PC muscle tone go to
www.bladderfreedom.com for a free audio course!

There are many glands and ducts in the urethral sponge. When your G-Spot is stimulated, there's a greater chance that you will experience a gush of fluid (and not necessarily just when you orgasm), that will come out through the urethral opening. It is very similar to male ejaculate but has no sperm in it. It is clear, thinner than vaginal fluid and somewhat musky scented, loaded with pheromones.

> Female ejaculation is quite normal! Some women tell of ½ cup or more of liquid squirting out of them!

There are women everywhere sniffing soaked sheets because they think they have urinated while love-making. I'm here to say:

"STOP – you've just experienced female ejaculation."

> Tip for men: if you're performing oral sex on your lady and you know she squirts, you may want to move your face off to the side when she gets ready to orgasm so you don't drown in her juices.

Once this happens to you the first time, it seems like a switch has been thrown, the mind-body connection is made. You will ejaculate more frequently. You don't need to have direct G-Spot attention since pressure from your aroused and swollen tissues, combined with strong PC muscle tone (the pubococcygeus muscle) may be all it takes to send out a gushing stream of your ejaculate!

I remember a particular presentation I had given on female ejaculation and the G-Spot. A woman came up to me afterwards with tears in her eyes. She had been experiencing female ejaculation for over 15 years and both she and her husband thought there was something wrong with her. She felt defective and had been too nervous and embarrassed to ask her doctor about the fluid that was expelled whenever she made love. She was so **relieved** to discover she was not only healthy but quite normal!

To recap on female ejaculation, as you build towards orgasm and sense a fullness or bladder pressure, bear down and push your way through it. Be confident you won't urinate and enjoy the sensation. You just might ejaculate!

Embrace your individuality. Honour and respect your Sexual Truth and it will reward you throughout your life!

What do you need in place before you feel 'ready' to play with yourself?

What do you need before you feel 'ready' to make love?

What do you notice about your two answers that is most powerful for you?

Is it okay if you don't like G-Spot play or you think it's fun but it isn't a huge turn on or you sometimes like it and sometimes you can't stand it?

Of course!

The beauty and magic of it is that it's so unique with each woman. Your breasts are different from anyone else's and you have a different set of wonderful circumstances solely yours that turn you on. Situations change over the course of your menstrual cycle, your moods, your point in life, your relationship, your week or even your day that affect different aspects of your sexuality. You are a distinctive individual whose sexuality is a living, breathing, changing creature.

YOUR *SEXY* MISSION

❑ Follow steps on pages 38 and 39 to assess what type of G-Spot stimulation appeals most to you.

❑ Answer the questions in this chapter.

❑ Prepare yourself to masturbate using your clitoris. This time, BEFORE you reach orgasm, slip your finger inside and vigorously stimulate the area that gave you the most pleasure from steps one through nine earlier. Become aware of the area with the most pleasurable sensations. Ease up on your clitoris or better yet, stop touching it and give some strong stimulation to your G-Spot. Then resume your clitoral play and stimulate both areas at the same time. See what happens!

SENSATIONAL *CELEBRATION*

❑ How will you celebrate your completed Sexy Missions?

❑ When will you celebrate? (Record the specific date and time and schedule it into your planner or calendar! Being detailed increases your likelihood of success.)

6

Sexy Toys to Stimulate the G-Spot
(OPTIONS)

"If I make a fool of myself, who cares?
I'm not frightened by anyone's perception of me."
Angelina Jolie, Actress

Would you rather pump up the tire on your Mercedes with a bicycle pump or use a gas station's air hose designed specifically for that task? Better yet, smile sweetly and get the hunky mechanic to do it for you. More on that in the next few chapters!

Isn't it so much more efficient to have the proper tool to get a job done right the first time? With the right G-Spot toy, you'll save time, prevent muscle strain, avoid cramps in your fingers, and maximize your efforts!

As mentioned earlier, when alone we're much more likely to orgasm quicker so practice with your G-Spot toy on your own to work out the kinks. You can show off your newfound expertise later!

All proper G-Spot toys are curved at the tip to allow for easier access. Since there are fewer nerve endings inside the vagina than outside in the clitoris, you need hard pressure or vibration. The easiest way to do

that is with a vibrator or a very firm dildo. Soft jelly doesn't work well so stick to harder plastic or even glass (though glass sex toys are quite expensive).

I don't recommend using a regular shaped sex toy because to get the end of it aimed at the right spot you need to contort your body or your arms in ways that can be awkward.

Lioness for Lovers carries a fabulous G-Spot vibrator (shown on the next page) that I love. The shaft is narrow so it doesn't keep you spread open and the large bulbous head at the end magically focuses on the G-Spot. It makes it easy even for your partner to find your G-Spot! And it's purple – my favourite colour.

> For all our toy options go to www.lionessforlovers.com/shop
> and see Chapter 13 for your special discount code.

Try different positions like you did when you used your fingers to see what you prefer. You can hold the vibrator in place and keep it still or you may find quick thrusting in and out is more effective for you. Once you're turned on, your vagina can handle pretty intense and hard activity so have fun experimenting.

As long as your fingers are clean and your nails are clipped you can explore with no worries. Your toys should be cleaned with soap and hot water or anti-bacterial spray. As long as they're clean and smooth with no rough edges, go for the gusto!

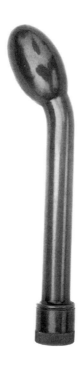

G-Spot Vibrator

YOUR *SEXY* MISSION

❑ By now you have enough information to try G-Spot stimulation with a toy. Use one of your own toys, go to a sex toy store in your town, go online or check out our website at www.lionessforlovers.com/shop to acquire a G-Spot toy that tickles your fancy. I suggest you look online first to see what you like, make a list of the qualities that you want and what you don't and go from there. Make sure you also have an excellent water soluble lubricant.

SENSATIONAL *CELEBRATION*

❑ How will you celebrate your completed Sexy Missions?

❑ When will you celebrate? (Record the specific date and time and schedule it into your planner or calendar! Being detailed increases your likelihood of success.)

7

The Male G-Spot: Prostate Pleasure (Options)

"I love you, not for what you are,
but for what I am when I am with you."
Ray Croft, Poet

Looking for a new way to please your man? Drive him wild with your daring attitude and open up a whole new avenue of lovemaking with the male G-Spot!

Your man has a prostate that is the male equivalent of our G-Spot. It is located about two inches inside the rectum and is about the size of a walnut. A lot of heterosexual men love anal play. They have nerve endings in their prostate which can make anal play a lot more sexually arousing for them than it is for most women.

Not all men receive pleasure from prostate massage or stimulation, just like not all women like G-Spot sensation. Once you've experimented he may decide he doesn't receive that much pleasure or it may even turn him off. Please respect your man's wishes just like you'd want him to respect yours!

Lots of men (with healthy prostates) reach orgasm strictly from prostate stimulation alone without even touching the penis. It can be a whole new way to reach orgasm – give it a try.

"Our relationship is one of gentle exploration. One day my partner told me he read an article about a couple that enjoyed male penetration as the man only came with prostate stimulation. My partner was a little uncomfortable with being "penetrated" but was curious so he asked me to experiment – a new experience for me too!

Once I had his penis stimulated orally, I applied some lubricant to my freshly clipped finger and slowly teased his anus before sliding it in. He told me what I should feel for and let me know when I found the spot. His arousal increased as I licked him and stimulated his prostate, he then exploded with what he said was a "wild" orgasm! A few days later while cuddling, he teased me that I had "popped his anal cherry" – a very sensual experience to share with a partner!" *Name withheld, Nanaimo, Canada.*

As with any type of penetration of any body orifice, cleanliness and lubricant are important – especially with anal play. You don't naturally lubricate anally so a good lube is ALWAYS required. Please don't use so called *"anal lubricants"* because they usually have a numbing compound in them. You want

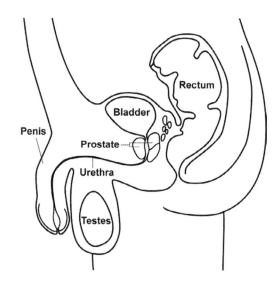

to pay attention to your body's signals for discomfort. Don't force or push your way into any body opening. If you feel pain, stop! With anal play, simply pausing for a moment to let your body adjust to the sensation is all that is usually needed before you can safely continue on. I suggest only those quite experienced with anal play use these numbing "anal lubricants."

You want to be vigilant about cleanliness with anal play since the bacteria that are naturally in your rectum should not be passed along to the vagina or you could end up with an infection. Always wash toys or fingers before they end up near your vagina. You also want to ensure that nails are clipped and trimmed well since the anal lining is delicate and a tear in the lining can make you very ill.

Start slowly using your tongue, small finger or small vibrator (our Microtingler is *perfect* for anal play) to tease and gently play in the area during manual or oral play with your man's penis. As long as you have lubricant and he is relaxed (never push!), just before he reaches orgasm, slip your baby finger or toy up into his rectum and witness an explosive orgasm. Once you pull him down from the ceiling, I promise you won't be forgotten if this is the first time he's experienced prostate stimulation!

It can be a very erotic practice for a woman to penetrate her man. Try it and see what you think!

Men often apply pressure to their perineum (super sensitive are between their anus and scrotum) when they masturbate and often don't realize the pleasure they feel is in part from external stimulation of their prostates.

YOUR *SEXY* MISSION

❑ Consider the idea of exploring anal play with your partner. What needs to be in place for you to make this happen? Set it up!

SENSATIONAL *CELEBRATION*

❑ How will you celebrate your completed Sexy Missions?

❑ When will you celebrate? (Record the specific date and time and schedule it into your planner or calendar! Being detailed increases your likelihood of success.)

Advanced Sexual Techniques for Blended Orgasms, Oral Sex Tips, and More!
(NEXT STEPS)

"Too much of a good thing can be wonderful."
Mae West, Actress

Are you ready for some advanced love-making techniques? This chapter will help you stand out even more in the bedroom. You've seen those women on the dance-floor who seem to have all the right moves? Well now you can have even more of the right moves in bed!

SPECIFIC SEXY TIPS & THINGS TO TRY!

- Have your partner manually stimulate your clitoris while penetrating you at an angle that stimulates your G-Spot. Be patient as this takes some co-ordination!

- Have your lover practice the 'come hither' motion with a finger or two on your G-Spot (or using a toy in side you) while performing oral sex. This also takes practice but well worth it for mind-blowing orgasms.

∽ Have your lover insert a clean, lubricated index finger into your vagina and start at 12 o'clock position and move all around the clock while you provide a number from 1 to 10 on pleasure scale or just moan softly or loudly according to how much you love it. Don't make it too scientific – get creative with your score keeping!

∽ Experiment with ice cubes or hot drinks in yours or your lover's mouth to vary tongue temperature on your clitoris and labia and his penis.

∽ Be careful with mints and menthol cough drops in your partner's mouth which is often used to lick, kiss and suck on a woman's clitoris. That may feel fabulous for one woman yet may be totally uncomfortable for another!

∽ Encourage your partner (or try this when you masturbate) to go from clitoral stimulation to G-Spot, then back to clitoris and then G-Spot and then both at the same time. It will drive you wild with desire. He won't want to stop too many times when you're getting close to climax or else you'll have to both start all over again. Communication is key!

- Try using a vibrator on your clitoris while being penetrated with a toy or a penis for a full out sensory overload.

- Try using a small vibrator such as a bullet or Lioness' Microtingler inside of you while being penetrated by his penis. This way he gets the pleasure of making love to a vibrating vagina.

- Consider adding anal penetration to any of these for an intense experience and a very full feeling.

YOUR *SEXY* MISSION

❏ Pick three extra techniques that you haven't tried yet and set a date on your calendar to practice one on one night, one in an afternoon, and try one in the morning!

❏ _____ Date: _____

❏ _____ Date: _____

❏ _____ Date: _____

SENSATIONAL *CELEBRATION*

❑ How will you celebrate your completed Sexy Missions?

❑ When will you celebrate? (Record the specific date and time and schedule it into your planner or calendar! Being detailed increases your likelihood of success.)

9

Bonus Material — Sacred Sexy Circle Experience (Enhance)

*"Be ready at any moment to give up what you are
for what you might become."*
W.E.B. Du Bois, Author

Do you want to develop sexy new habits, build your sexual self-confidence and advance your sensual development? There is a proven scientific method to do just that! This whole Chapter of bonus material is actually a Sexy Mission to help you reinforce what you've learned so far and help you reach your sexual potential even faster!

Find a comfortable, quiet, place free from interruptions and distractions where you can listen to all three audio tracks of the Sacred Sexy Circle process. Download them from our website at www.lionessforlovers.com/sexycircle.htm. The three tracks are about 50 minutes long but the process itself will only take about 30 minutes. Track one clarifies the process, the second track explains the science behind the process, and the final track is the complete 30-minute coaching process led by me to assist you on your Sexual Empowerment journey.

After you have done the Sacred Sexy Circle process I invite you to answer the following questions.

There are only right answers. Whatever way you experience this process is perfect for you!

How was this experience for you?

How will your Sacred Sexy Circle assist you with your G-Spot play?

If you embrace the vision of you that you saw in your Sexy Circle, who will you be in the world?

Who benefits from you being that person? Who else?

Email info@lionessforlovers.com if you have
any questions about the process.

YOUR *SEXY* MISSION

❑ Listen to the Sacred Sexy Circle process audios.

❑ Answer the questions after you complete the process.

❑ Repeat stepping into your Sexy Circle every day for at least three weeks and try for 30 days in a row. This is part of the science of ensuring you will feel, believe and be all that you want to be! Mark the days you do it to monitor your success.

❑ _____ ❑ _____ ❑ _____

❑ _____ ❑ _____ ❑ _____

❑ _____ ❑ _____ ❑ _____

❑ _____ ❑ _____ ❑ _____

❑ _____ ❑ _____ ❑ _____

❑ _____ ❑ _____ ❑ _____

❑ _____ ❑ _____ ❑ _____

SENSATIONAL *CELEBRATION*

❑ How will you celebrate your completed Sexy Missions?

❑ When will you celebrate? (Record the specific date and time and schedule it into your planner or calendar! Being detailed increases your likelihood of success.)

G-Spot Communication With Your Partner
(SHARE)

"You never lose by loving. You always lose by holding back."
Barbara De Angelis, Author

Interested in bringing your partner up to speed on your discoveries? Start by being willing to expose your true desires a little at a time. You may feel vulnerable yet it can be incredibly rewarding with someone you love and trust. Some of you will do this entire process with your partner from start to finish and that's perfectly okay too!

What are the reasons for including your partner in your G-Spot exploration?

(Examples: a more exciting relationship, more fun in bed, better communication)

If you had that fully and completely, what would that give you?

(Examples: more closeness, deeper sharing)

If you had that fully and completely, what would it give you that was deeper and even more important?

(Examples: more secure in relationship, more confidence)

If you had that fully and completely, what would it give you that was deeper and even more important?

(Examples: feelings of peace, calmness, deeper love)

Can you see why it might be important to tell your partner what you've been doing and what your desires are? This may seem challenging for some of you. The following is a checklist to help you plan and prepare what you are going to say, how you will do it, where and even when. Consider this only a beginning. The sexual conversation should never be a one-time deal – it's a life-long event!

SEXUAL CONVERSATION CHECKLIST

✍ Plan out all the points you might want to say.

✍ Rehearse what you want to say.

✍ Pick a time good for both of you (NOT in bed). This also means asking him if it's a good time.

✍ Think of an appropriate place to begin the conversation.

✍ Talking is not always the best method of communicating so explore your options. Some suggestions are noted below.

As you know when you rehearse something, you have a much better chance of success.

As for time, wait until the conditions are relaxed, inviting and loving when you won't be rushed and you may even have time for some lovemaking if things go really well!

You may also want to choose your location carefully. Over brunch is probably better than while driving through rush hour traffic on your cell phone.

There are so many ways to communicate. Consider writing your thoughts or ideas down in a note, a long letter or perhaps a romantic card. Try recording on a digital recorder, a webcam or a video camera to get really creative. You can always leave this PlayGuide laying about as a conversation starter. Maybe a good old fashioned telephone conversation, just remember to check that the time is good for both of you! A final suggestion is to bring in a third party, perhaps a friend or relative to start the ball rolling.

Remember to put yourself in your partner's shoes and maybe see where they might be coming from around the idea of new sexual territory. He may not share your same enthusiasm. Be conscious of this as you make your choices and try to keep things romantic and fun!

You can introduce some of what you've learned by showing them while you are making love. Just be mindful and think it through first so it's a fabulous experience for you both!

If you had any challenges with this section or wish to explore this area further, contact Lioness for Lovers and inquire about coaching with one of our Intimacy Coaches.

YOUR *SEXY* MISSION

❏ Answer the questions at the beginning of the Chapter.

❏ Decide which three ways will be the easiest for broaching the subject with your partner. Is there anything that could get in your way? Write down how you will handle that.

❏ _____

❏ _____

❏ _____

SENSATIONAL *CELEBRATION*

❑ How will you celebrate your completed Sexy Missions?

❑ When will you celebrate? (Record the specific date and time and schedule it into your planner or calendar! Being detailed increases your likelihood of success.)

Advanced Techniques for Communication
(SHARE)

*"Love comes when manipulation stops; … When you dare to reveal
yourself fully. When you dare to be vulnerable."*

Dr. Joyce Brothers, Psychologist

The absolute most important point to remember for an amazing sexual
relationship is to keep the lines of communication wide open with
your partner. This doesn't mean that you have a running conversation
or play-by-play while you make love. Though for some, that works just
fine! Stay in tune with each other not only while having sex but also in
other areas of your life. When you are aware of your partner's moods,
situation and physical well-being, you're less likely to try to get them
between the sheets when it really isn't the best time for them.

Don't ever assume you know what is going on for your mate.
You can guess, but always check in to make sure your assumptions
are valid.

Especially if your partner is of the opposite sex, there are some differences in how we communicate so always verify your assumptions.

What is one of the best ways to know what your partner wants?

A gold star for you if you said "ask them!" They may not always tell the truth, but that's a whole other conversation. There is a trick to asking though. Instead of asking, "do you like this?" or "am I doing this well?"

To which they're likely to reply "yes, of course it's great" (which may not be the entire truth) try the following instead:

Ask specific questions of your lover. While using your fingers, mouth, penis (for the men reading – P.S. good for you!) or a sexy toy on your partner, ask something such as:

"what specifically would work even better for you?"

"would you like more pressure or less pressure?"

"should I go more to the right or left?"

"is there anything I can do differently right now?"

"do you prefer up and down?"

"should I thrust now or be more still"

Or the lovely:

"what else can I do for you right now?"

While experimenting please remember that you both have the right to change your mind the next time you do it or possibly even *within* your lovemaking session.

> *"Assumptions are the termites of relationships."*
> *Henry Winkler, Actor/Director*

YOUR *SEXY* MISSION

❏ Pick one question to ask your lover the next time you
make love and ask it! Have two back-up questions
ready in case it works really well and try those too!

1. _____

2. _____

3. _____

SENSATIONAL *CELEBRATION*

❑ How will you celebrate your completed Sexy Missions?

❑ When will you celebrate? (Record the specific date and time and schedule it into your planner or calendar! Being detailed increases your likelihood of success.)

Sexy Positions for G-Spot Stimulation
(SHARE)

"New love is the brightest, and long love is the greatest,
but revived love is the tenderest thing known on earth."
Thomas Hardy, Novelist

Different positions give different sensations and some are more
comfortable than others. Any position where the man penetrates you
from behind is great. These positions allow the head of the penis
to hit the front wall of the vagina which is the access point to your
G-Spot. Remember the more slippery you are, the smoother and more
pleasurable it is for you both. Have fun and experiment with your
variations on these favourites.

You can listen to some fun and sexy podcasts (audio recordings
available on the internet) all about sex positions with
Dr. Patti Taylor and myself as she interviews me on this fun topic.
Go online to http://www.lionessforlovers.com/pages/media.htm.

I recall a young woman who was very shy and wanting to know if I could help her. She mumbled quietly and stared at her feet and shared with me that she could only orgasm when her partner penetrated her and no other way. Clitoral stimulation didn't quite do it for her. She was feeling quite awful and thought something must be very wrong. I assured her that she was indeed quite healthy and just not in the 'typical' or 'usual' category. She was fortunate to be able to orgasm this way since a lot of women have the opposite problem. I encouraged her to masturbate with a dildo inside of her when she wanted to orgasm and she was quite happy with that solution.

So you see, it really is all about perception.

> Please send me your favourite position and I'll post it on my Sexy Blog (online web log). Visit Kim's Sexy Blog by clicking on the menu at www.lionessforlovers.com.

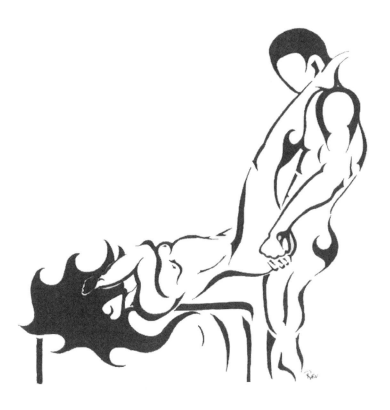

In the above 'Elevated Missionary' position you can still look in each other's eyes while getting G-Spot pleasure. If you prop your bottom up with pillows, it should be quite comfortable for both of you. Just be careful of his shoulders if you get really excited as you can put a lot of strain on them!

'Spooning' (which is laying on your sides facing the same direction with the man behind) is a comfortable and romantic position where you can snuggle right in together. It's also great for pregnant women. It may not be as easy for quicker thrusting but is still lovely on a Sunday morning! It is also a helpful position for women whose male partner is a bit too long for comfort since it is harder to get full, deep penetration this way.

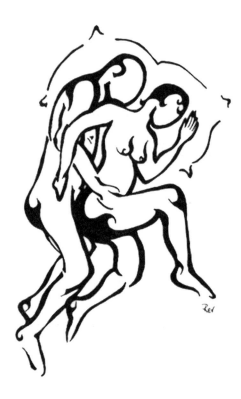

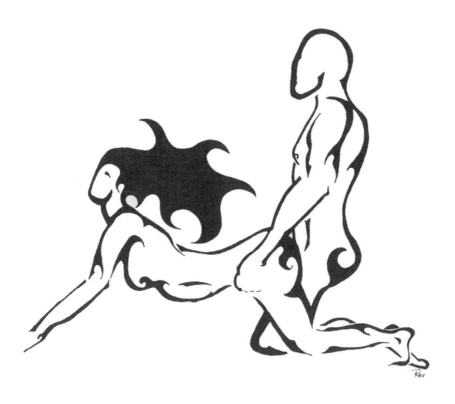

Women usually love the above position yet few know it's because they're likely getting G-Spot stimulation. 'Doggy-Style' is a fabulous way to hit your G-Spot. You may need to experiment with angle and the level of your hips, but have fun practicing! If you're uncomfortable on your hands and knees you can always prop your hips up with some pillows. Alternatively, lean over a table, the bed or couch arm for support!

The woman can adjust her body angle by arching up with her arms very straight or laying almost flat to vary the angle as well. Experiment!

We have the most control over intercourse in the 'Woman-On-Top' positions illustrated here. In this sexy position, we also control the intensity of speed and thrust and the exact type of G-Spot stimulation we want to receive. Experiment with your hips to see how you can control the G-Spot attention. You can invite your man to be still while you control all the action or you can work it together.

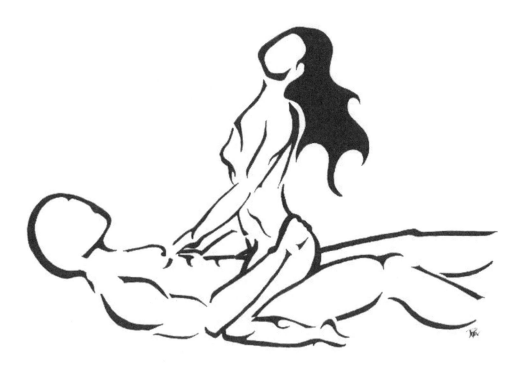

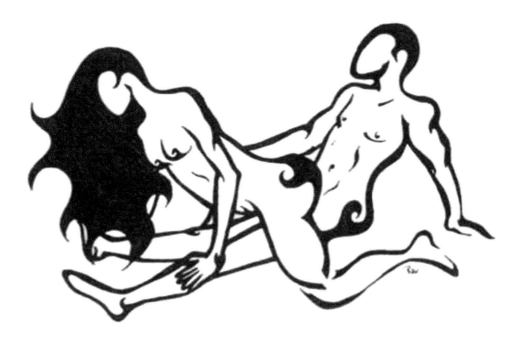

When you are turned around and facing your man's feet, you're in the 'Reverse Cowgirl' position. Try this one to spice things up a little! You may find you're less inhibited this way since you can't see each other. Use this to your advantage and you go, girl!

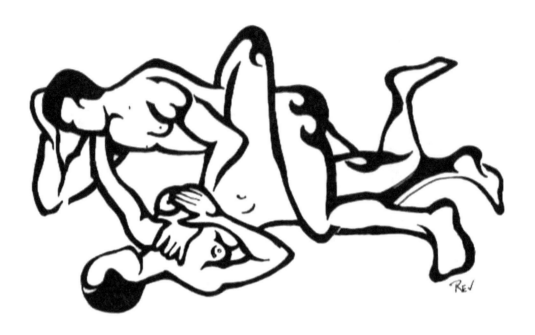

If your man enters you like in the drawing above, you can both enjoy squirming about until you get just the right pleasure angle. A great, relaxed position, it's wonderful if you have arthritis or are overweight.

I love this position for intimacy and deep penetration.

This position also allows for deep penetration and tender intimacy, yet strength is required from both of you to keep the momentum going. Play around to see what works best for you!

If you long to be on top, but don't yet have the confidence, consider surprising your man by putting a blindfold on him and then ride away! You may feel much less vulnerable if he can't see you. You can also put the blindfold on yourself and watch your inhibitions melt away…

All of these positions are wonderful because they allow you to play with your own clitoris and masturbate while getting G-Spot stimulation combining for powerful orgasm potential. You also leave room for your partner to play with your clitoris as well!

Aggressive thrusting during intercourse will give you much better G-Spot gratification than slow in and out. Your lover can experiment with angle, hardness and quickness of thrusts. He simply needs to listen for your reaction. Remember, it's your job to let him know what works!

It's much easier for your partner to access your G-Spot than it is for you – kind of like a built-in sexy toy for two. What a wonderful thing for you both to share!

> If you always do what you've always done, you'll always get what you've always got!

The following story is not for every one. Please note that all were consenting and enjoyed themselves.

Cunning Minx, host of a Poly Weekly podcast about polyamorous relationships shared this fun story with me. (Polyamory is the practice of having multiple loving relationships at one time.)

"I just discovered in the last year, at 38, that I can squirt – but only when someone takes boxing gloves and punches my [butt], vibrating the G-Spot from the exterior and behind. Freaky, huh? The first time it happened, a woman was using my [butt] like a punching bag for two-minute rounds, and her male [partner] noticed my reactions. Even though I was wearing panties (so he couldn't see the squirt), he unobtrusively proffered a towel after her final bout."

Though this method isn't one I recommend, it shows you that if you're creative, you never know what surprises are in store for you!

Sex positions illustrations by Rev are available for purchase on our website! Email info@lionessforlovers.com for more information.

YOUR *SEXY* MISSION

❑ Select three positions that you'd like to try. In your next three lovemaking sessions, try at least one of them each time.

❑ _____

❑ _____

❑ _____

SENSATIONAL *CELEBRATION*

❑ How will you celebrate your completed Sexy Missions?

❑ When will you celebrate? (Record the specific date and time and schedule it into your planner or calendar! Being detailed increases your likelihood of success.)

13

Follow Through and Support
(Success)

"Just don't give up trying to do what you really want to do.
Where there is love and inspiration, I don't think you can go wrong."
Ella Fitzgerald, Singer

Congratulations on reading this far! We've covered a lot of sexy territory that may have been fun, scary, exciting and hopefully inspiring! Now you know:

- where your incredible G-Spot is

- ways to stimulate it that work best for you

- the mystery of female ejaculation

- all about sexy G-Spot toys

- how to reach the male G-Spot

- some advanced sexual techniques to make your sex-life sizzle

- ways to share your G-Spot with your partner, and

- the best G-Spot sex positions for you

You've broadened your sexual horizons by doing the Sexy Missions and the Sensational Celebrations!

What are some of the favourite things you've learned?

What gave you your best G-Spot sensations?

How will you incorporate that into your love-making?

What have you discovered about your partner that is powerful?

More importantly, what is the most amazing thing that you have discovered about yourself?

What specifically will you do now? (with the PlayGuide, your lover, and especially yourself)

By now, you should have fulfilled lots of Sexy Missions and enjoyed plenty of Celebrations of your successes along the way. Everything you have accomplished, learned and participated in is significant, but don't stop here. The key to healthy sexuality is consensual activity that brings you pleasure. Your sexual energy is your life force. It keeps you vital, strong and living a full and complete life. Embrace your journey of continual sexual empowerment.

Studies show the single most important factor for successful change is support.

You can continue to get support and advice about everything I've laid out for you. Join me on my free Sexual Truth tele-conference calls at http://tinyurl.com/59mmry and sign up for my monthly Ezine (online newsletter delivered to your Inbox) "Unleash your Inner Lioness!" from http://tinyurl.com/5rug7y today.

Your 10% special discount code for online product orders is PG10.

You can also participate in a more structured environment to keep you inspired and accountable helping you push your sexual envelope and explore the layers of your sexuality in our exciting online programs. Or you can hear me speak at live events. Check out www.lionessforlovers.com for more information or log-on to my Facebook page searching for Kim Switnicki. Let me know what the PlayGuide has done for you!

If you want personal coaching, please go to the website and try the Coachability Quiz (Step two on the web page) to see if one-on-one coaching is right for you and email me your results. Learn more at http://www.lionessforlovers.com/pages/sex-life-coaching.htm.

As mentioned in Chapter 4, the program for you to gain "Freedom from your Leaky Bladder" is available on our website. Go to www.lionessforlovers.com/shop under Lioness Exclusives if you want to enjoy tighter muscles for lovemaking and be able to cough, laugh or sneeze with no fear of accidents. No woman of any age should dribble or leak so take back control of your body.

As **another bonus**, here is the link so you can receive the complete audio download of my live 80 minute "Unleash your G-Spot" workshop. So grab your lube, toys, and towels and download now before you forget. Use it as the next step in your journey towards learning the magic secrets of fulfilled women everywhere. Visit http://www.lionessforlovers.com/g-spot.htm tonight!

Let this be the continuation of your journey and the beginning of our partnership together. I've enjoyed sharing my **L.I.O.N.E.S.S.** technique (**L**earn, **I**nvestigate, **O**ptions, **N**ext, **E**nhance, **S**hare, **S**uccess) for getting you to G-Spot heaven. As you evolve and grow, I look forward to continuing to be of service to you in any way that I can.

Many years from now, as you face the last moments in your life, what will you look back on to say you wish you had done more of? If you're like many of us, your answer will have something to do with love and relationships – and that's what this G-Spot PlayGuide has been all about.

YOUR *SEXY* MISSION

❑ Celebrate completing this stage of your never ending journey of sexual exploration. Celebrate you, your lover, your life, and your G-Spot!

❑ What are the next steps you will take on your journey to reach your sexual potential?

SENSATIONAL *CELEBRATION*

❑ How will you celebrate your completed Sexy Missions?

❑ When will you celebrate? (Record the specific date and time and schedule it into your planner or calendar! Being detailed increases your likelihood of success.)

About the Authors

KIM SWITNICKI, ACC

As founder and CEO of Lioness for Lovers, this International Speaker focuses on helping women Unleash their Inner Lioness by providing Fun Sex Ed. for Women! As a Sex Educator, and internationally accredited Coach, she specializes in providing women ways to improve their sensual, sexual selves to experience deeply satisfying relationships – even if only with themselves.

For over 25 years she has spoken with thousands of women promoting healthy, positive sexuality. Kim has been profiled in newspapers and international webcasts. Her website and products are well regarded as sources for empowering you to enhance your lovemaking, live your sexual truth and transform your whole life.

She works with clients both individually and in groups through educational and informative seminars, workshops, coaching, and is often asked to speak on women's sexuality issues.

Lioness for Lovers has been established since 1998 and continues to grow and develop along with Kim's desire to assist as many people as possible reach their sexual potential!

Kim lives on beautiful Vancouver Island, BC, Canada with her husband Barry and their two cats.

Let Kim guide you as you embrace your sexuality
in ways you've only dreamed of.

Lioness for Lovers is not for the woman who has everything, but for the woman who knows there's more!

CONTACT:

Lioness for Lovers
#201, Stn A
Nanaimo, BC V9R 5K9
Canada

Email: **kim@lionessforlovers.com**
Phone: **250.753.8692**
Toll Free: **1.888.475.2948**
www.lionessforlovers.com

BARRY SWITNICKI, PCC

Barry has been a Transformational Coach, Educator, Mediator and Speaker for more than 25 years. He has worked with countless individuals, couples and families helping them be supremely successful in their lives and relationships. He also trains, mentors and debriefs new and established Coaches and other practitioners enabling them to be more effective with their clients while taking better care of themselves.

Barry has also worked extensively with couples of all sexual orientations, to transform and re-invent how they interact, work and play together! He is one of the few Professional Certified Coaches in Canada accredited through the International Coach Federation and helps clients worldwide.

He impassions people to explore, challenge, and stretch to be the absolute best they can be.

ARE YOU BEING YOUR BEST?

CONTACT BARRY THROUGH:

Lioness for Lovers
#201, Stn A
Nanaimo, BC V9R 5K9
Canada

Email: **Barry@ChangeMentors.ca**
Phone: **250.713.2508**
Toll Free: **1.888.475.2948**
www.lionessforlovers.com

RESOURCES ON OUR WEBSITE

Go to the Resources page on our website for a list of sexual health info, and personal and business websites to help make life easier for you and others.

For wonderful books on sexuality, refer to www.lionessforlovers.com/shop and click the category "Sensual Books."

If you would like Kim to speak at your event, please call toll free at 1.888.475.2948 to check availability. For more information visit http://www.lionessforlovers.com/pages/speaking.htm.

To order extra copies of this book for sisters, moms, daughters or girlfriends call 1.888.475.2948 or visit www.lionessforlovers.com to order.